The Art and Adventure of
Making Rubbings

By Virginia Wade Ames

2016

The Art & Adventure of Making Rubbings

All photos are by Janis Howatt Willkom, except for those of the Ashurnasirpal II rubbings which are by Martha Ames Burgess.

ISBN 978-1-523284-01-6

CRAFTS & HOBBIES
ART/TECHNIQUES/GENERAL

QUANTITY PURCHASES: Companies, professional groups, clubs, and other organizations may qualify for special terms when ordering quantities of this title. For information e-mail VWA@flordemayoarts.com.

This book is printed in the United States of America

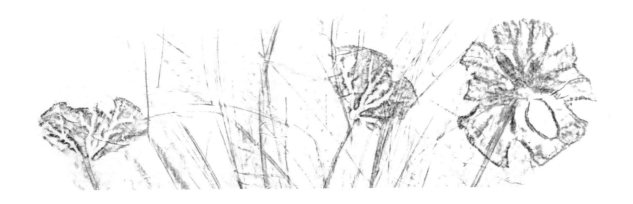

Dedication

I *dedicate this fun book to explorers, young and old, who want to open their eyes to new textures and details in the world around them.*

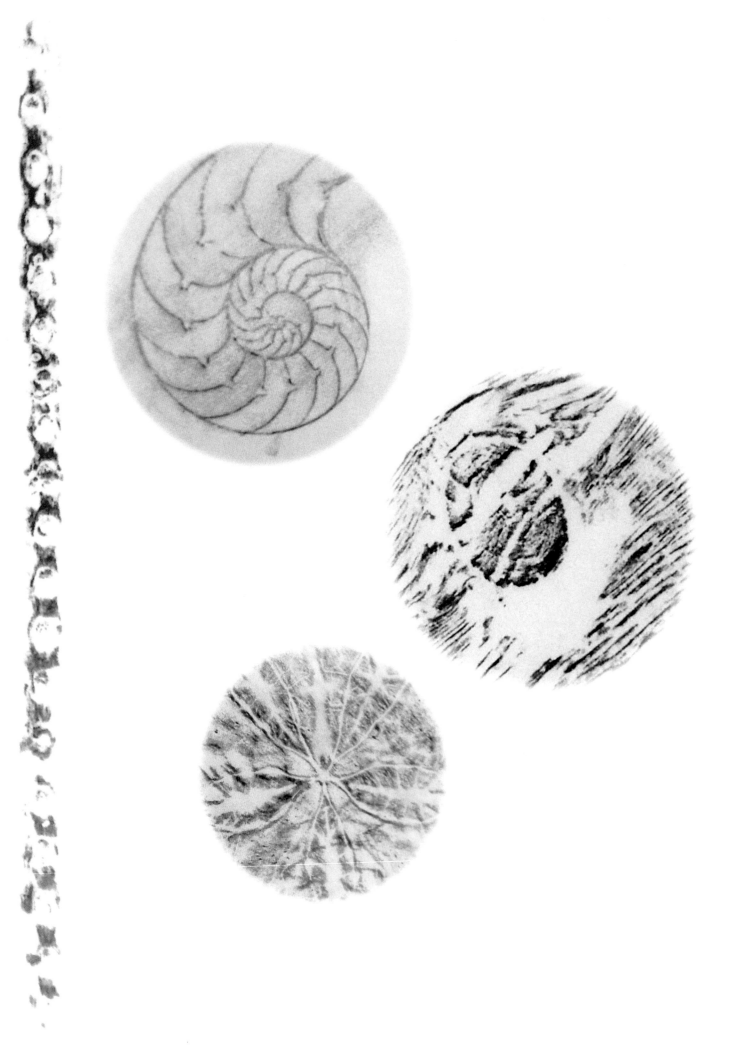

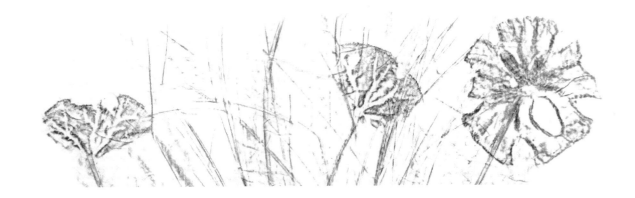

Contents

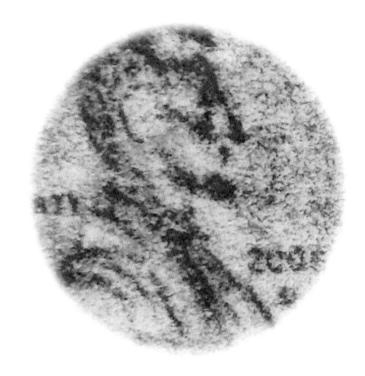

The Art and Adventure of Making Rubbings

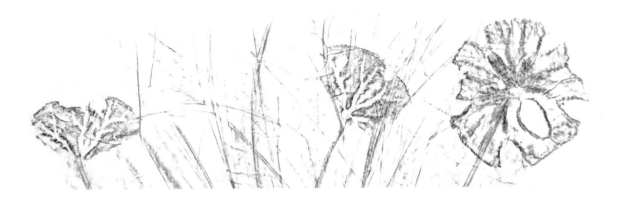

Introduction

What Is a Rubbing?

Do you know what a **rubbing** is? Rubbings are a fast and fun activity and an art form that enhances interesting textures. Making a rubbing is like making a detailed tracing that picks up the high points on the object under the paper. Using a flat-sided wax crayon or the side of a lead pencil, and a cover sheet over the textured or pressed object, you simply rub pencil over paper and—VOILÁ!—many new things become visible.

Have you ever seen a rubbing of a coin? Perhaps you have "rubbed" a coin yourself. If it was a penny, you probably saw a tiny image of the head of Abraham Lincoln emerge clearly on the paper as you rubbed. With rubbings, details show up that you can't see well with the naked eye. Suddenly, you're able to identify features in the image that you never even noticed before. You might find yourself exclaiming things like, "Wow, look how the hairs in that beard of Abraham Lincoln become visible!" Details seem to pop out as you carefully brush the pencil lead across the paper atop the penny.

In this book you will learn about the simple supplies you will need and some clever techniques to use for making your own rubbings. I hope YOU get inspired by the pictures of rubbings I've made over the years to get you started with a few ideas of your own. May rubbing open up new discoveries for you—of days gone by, living Nature, natural history, and cultural beauty in this wonderful world around us!

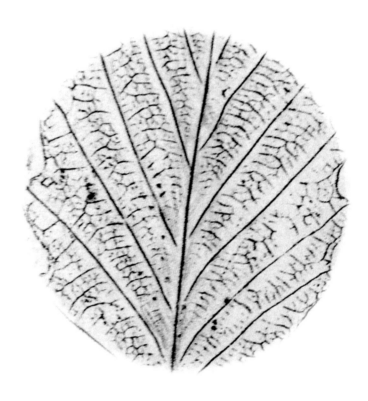

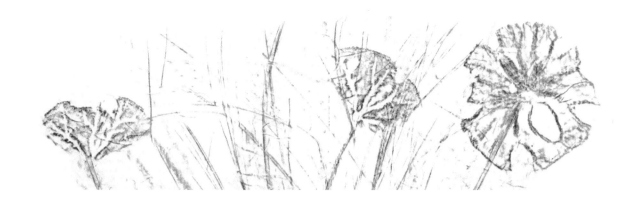

What Makes a Good Rubbing?

Sometimes people make rubbings of gravestones so they can learn more about history or their own ancestors. The names and dates on gravestones are sometimes so old and weatherworn that they are virtually unreadable. Then, amazingly, when you rub the gravestone surface with paper and wax pencil, the obscure dates, spelling of names, and details of history become *legible*. I had the opportunity to make one rubbing of a special granite headstone that told an unusual story I really liked, so read on—a copy of the gravestone rubbing appears among the illustrations in this book ...

Plaques on old buildings can reveal interesting secrets as well. I once found a metal sign on an old government building that revealed an obscure bit of historical fact. It showed the real reason why the colonists first got together to compose the Constitution of the United States. *History can be revealed with rubbings.*

And *natural* history can be revealed as well. Beautiful details of plant growth or animals can be seen more clearly. I have made rubbings of unique desert grasses and blossoms. The floral details emerged with rubbings that my eyes never saw.

One time when I was on vacation at the Atlantic Ocean seashore, I found and collected wonderful shells to be used later for making rubbings. As you read on you'll see interesting textures and patterns of the sea life and plant life I discovered through rubbing.

The most fun is finding and collecting textured objects, like layered sandstone, seashells,

weathered wood—or pressing soft objects like ripple-y seaweed, dry weeds, shapely leaves, or bark. Anything that catches your eye is worth using to make a rubbing. When I perfected my style, I made a giant rubbing of a rare stone carving of an Assyrian king who lived centuries before the time of Christ. By rubbing, I brought to light some ancient writing even the historians had not seen.

You can make an interesting rubbing of almost anything that has a surface texture, and it really doesn't have to be a flat surface either. Seashells are fun to rub, because they are quite sturdy and come in so many different shapes, sizes, and texture designs. Pictures of rubbings that I've included will show you better than words the results you can achieve. Each illustration also provides ideas and techniques to try.

There is so much you can discover! When you are on vacation or visiting a city, a park, or museum, you, too, may see many new things that would be enticing to rub. Be sure to pack your rubbing paper and flat pencils, which are described in the next chapter, and have them with you wherever you go. If you're in a public place, you may need permission to do a rubbing, but rubbing solid items should not do any damage.

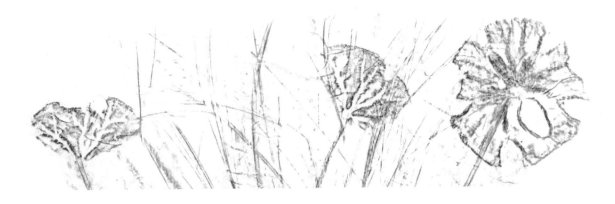

2

Supplies for Rubbing

You need only a few tools to make all kinds of rubbings.

1. Plain Paper

Thinner paper works the best. The paper must not be too thick, and it should be plain. Tracing paper works well. (Newsprint is too fragile. Watercolor paper is too thick. Blank notebook paper may be OK.) If your paper is thin it must be strong. Test it—if your thin paper is strong enough it will be difficult to tear, which helps when rubbing bumpy objects or objects with high relief.

2. Tape

Masking tape or drafting tape is best because it will not tear your rubbing if you remove the tape carefully. You will use the tape to hold your paper in place on or around an object while you make the rubbing. It pays to buy good quality masking tape which sticks but doesn't tear your artwork.

3. Rubbing Pencils

For your first rubbings, practice with **black or colored pencils**: a) one that has soft lead, and b) another that has hard lead.

The sharper the lead on your pencils, the longer the surface of lead will be available to rub with when the pencil is held sideways.

4. Wax Rubbing-Crayons

You can also try a hard **wax crayon** of any color. Good old Crayola works fine, with its paper cover removed and used on the long flat side of the stick crayon. The crayons I like the most are known as "**cobblers' wax**," a black bar or disc of wax that covers a larger area. It is the crayon that "professionals" use. You can find cobblers' wax in artists' supply stores.

5. Glue

For temporarily stabilizing your object to be rubbed, you may want to use a non-permanent glue such as rubber cement, glue-stick, or children's white glue—any glue that can be peeled off easily later after you make your rubbing.

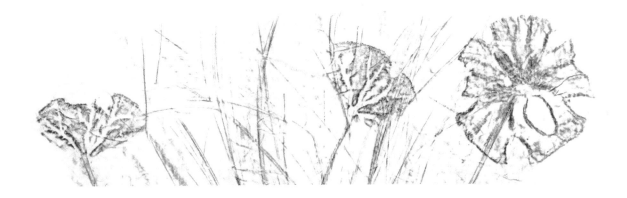

Illustrated Instructions for Making a Rubbing

You may want to practice your first rubbing using something small, like a coin. Here are the simple steps for getting started:

1. Put the coin on a flat surface, such as cardboard, poster board or plastic cutting board, that will not be damaged by glue. To prevent the coin from moving under your rubbing paper as you rub, glue the coin down to the base surface first. (Any object for rubbing that might slip around should be anchored.) Then, place rubbing paper over the anchored coin so that the paper extends well beyond the coin.

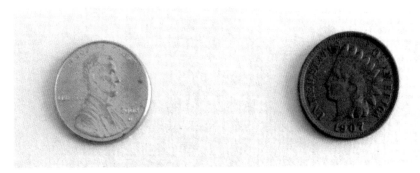

A new U.S. penny, an old U.S. Indian-head penny from the 1800s, and a U.S. Virginia quarter from the Commemorative State Series, temporarily glued to mat board

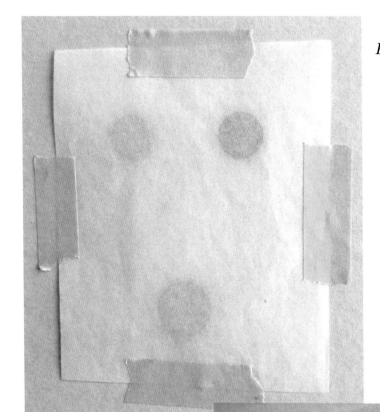

Paper over coins

*How to get an outline
of a rubbing*

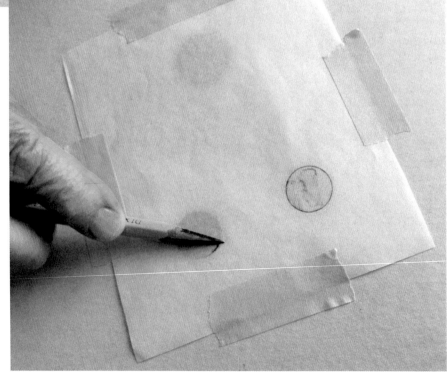

The Art and Adventure of Making Rubbings

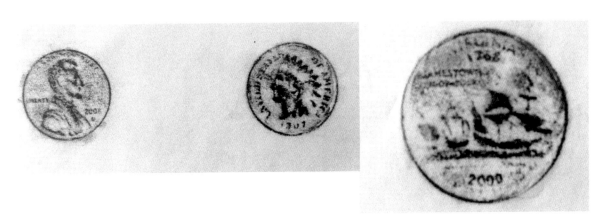

Rubbings of a 2006 Penny, Indian Head Penny, and a Commemorative 2000 Quarter

2. Gently rub over the entire paper surface with your pencil, crayon, or wax until you find where the object is under the paper. Once you find the object under the paper, you can then begin rubbing it harder all over the surface of the object and watch the details magically appear. It's good to know that most sturdy objects are not harmed at all by the rubbing process.

Read on—Chapter 4 presents illustrated ideas for rubbing a rich diversity of things around you!

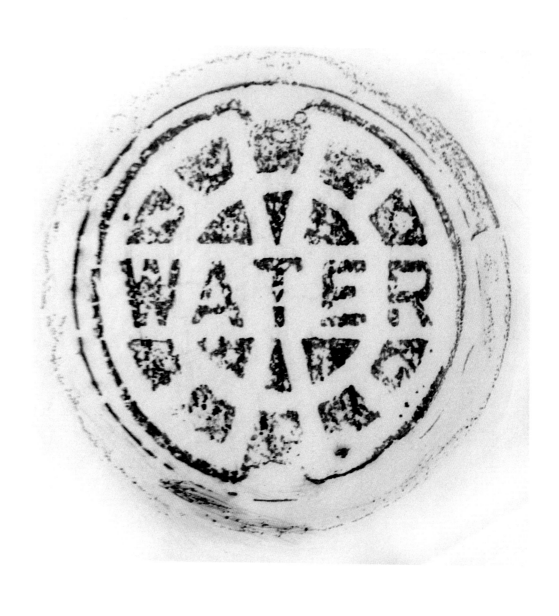

The Art and Adventure of Making Rubbings

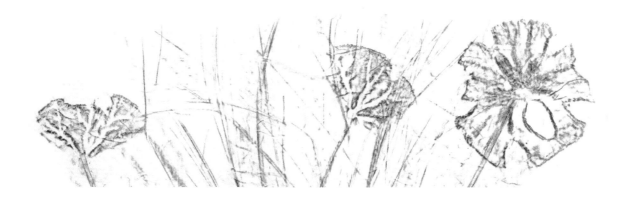

4

Discovery and Exploration

There are so many amazing things to rub! In this chapter you will see examples of many natural and man-made objects that have revealed their intricate texture or detail through the technique of rubbing. And, you'll see many creative effects that you can achieve with different rubbing tools.

Did you ever see a metal or heavy plastic cover set into the pavement of a sidewalk or public park that says "Water" or "Cable" or some other message for utility access? That metal or plastic plate tells where underground utility pipes are located. Such pavement plates are easy to rub because they are fairly flat with letters that stand out. Older parts of town usually have antique cast-iron utility covers, often with attractive scroll designs around the raised letters. The rubbing on the previous page shows a water main cover that was about 10" diameter.

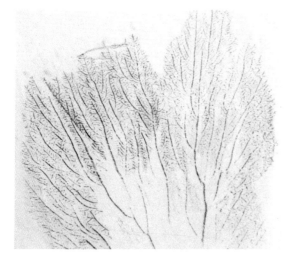

Rubbing of a sea fan, a lacey flat skeleton of a once-living coral

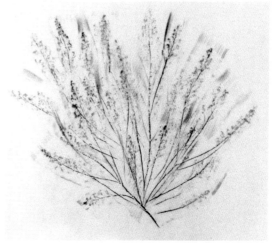

Rubbing of desert weeds pressed flat to make rubbing easier

An interesting item to rub is a fresh green leaf, but since it may take time to flatten the leaf, there is some planning and preparation you'll need to do ahead of time. Most likely, the leaf is curly or wavy, but if it is flexible, you can easily press it flat long enough to dry it before rubbing. Put the leaf between two pieces of paper or between the pages of an old magazine—it's like making a "leaf sandwich." Then, put the "sandwich" on a flat surface and place a weight, maybe a heavy book, on top. Let the leaf dry under the weight overnight. If the leaf started off damp, you may need to put fresh dry paper around the leaf and continue the pressing process. When the leaf is flat and dry, take it out and start your rubbing.

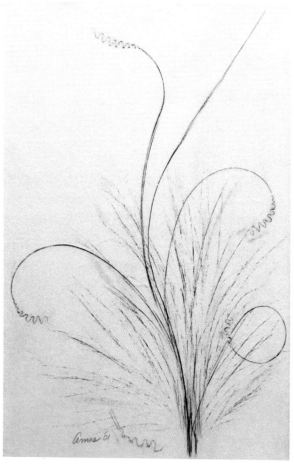

A composition rubbing of leaf tendrils of bear grass with other native desert grasses

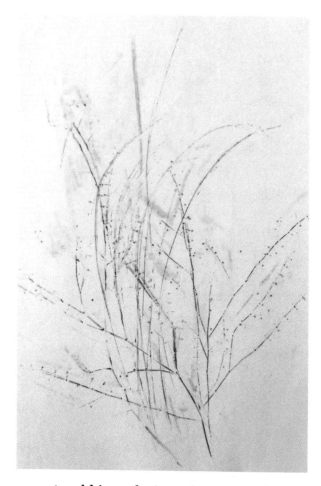

A rubbing of wispy desert weeds

By pressing your collected grasses or leaves flat under a book or in a magazine before you rub them you can capture so many details, including their seeds, graceful growth forms, and their textures.

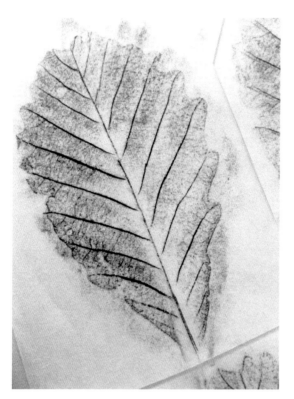

Leaf rubbing of chestnut oak showing details of leaf veins

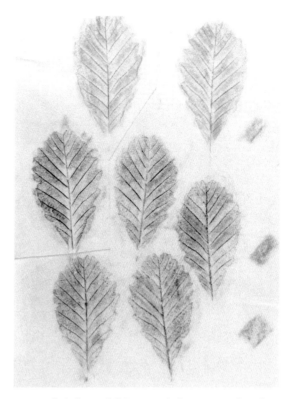

Multiple rubbings of the same leaf, red and black wax crayons

Below are tropical leaves from a garden in Key West, Florida. With delicate rubbing, every tiny vein appears.

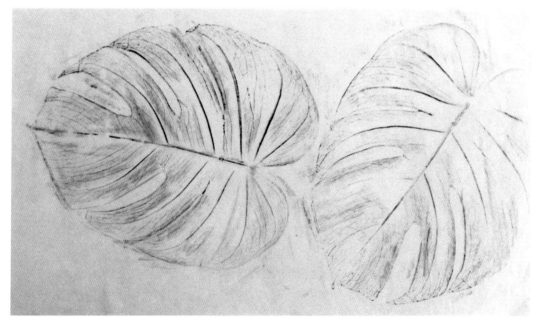

Cut-leaf Philodendron leaf showing the lobed spaces between the veins

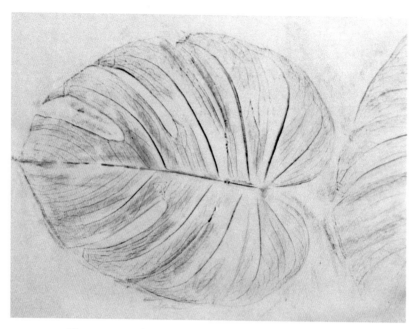

Close-up of cut-leaf Philodendron rubbing

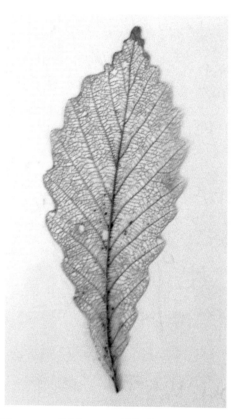

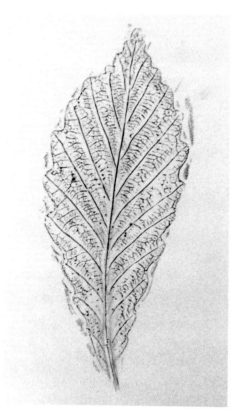

Not a rubbing —This is a real leaf, naturally dried and skeletonized down to its veins by insects, then pressed and preserved flat and protected for later rubbing

My rubbing of the dry skeletonized leaf

Below are sand dollars I found on the beach and brought home to rub. Of course, while you are beachcombing, you can always rub the objects you discover right on site. Sand dollars are thick in the middle, not flat like a penny, so make sure that rounded objects such as sand dollars and other shells are held in place and don't wobble as you rub them.

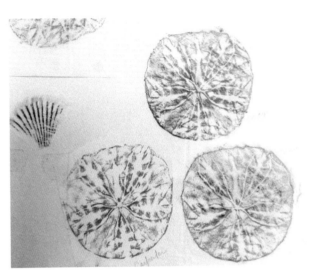

Sand dollar rubbings made with different color crayons

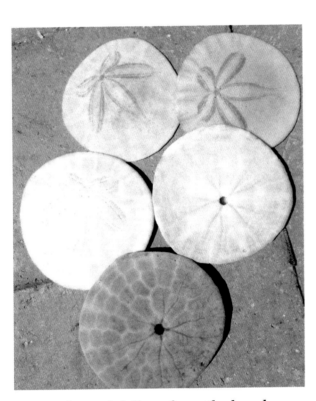

Real sand dollars from the beaches in Baja California, Mexico. These are the remains of the internal skeletons of an ocean-dwelling Echinoderm, a relative of sea urchins.

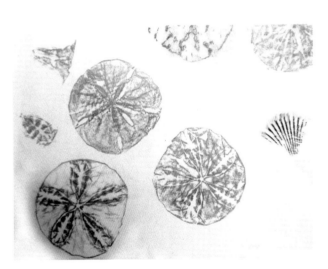

Rubbings made with blue pencil and graphite. Notice the little "angel" broken out from the center of each sand dollar and rubbed separately.

Below are rubbings of cast-iron deadbolt plates from a door lock in the historic mining town of Reál de Catorce, Mexico. They were rubbed with different types of materials—graphite, cobblers' wax, and pencil. Check out the different effect of each medium. It is fun to imagine how you might use these rubbing designs in other artwork compositions.

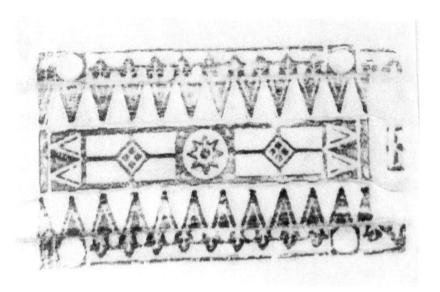

Rubbings of historic iron deadbolt plates, made with crayon, graphite pencil, and cobblers' wax

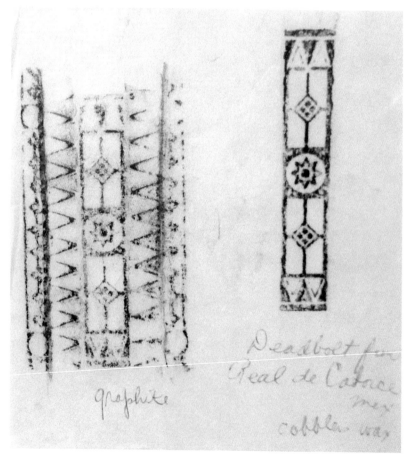

Below is a crayon rubbing of a fancy brass tray from India. What repeat designs can you see? Can you see images of people when you look closely? Rubbings can reveal minute details that one's eye would never notice!

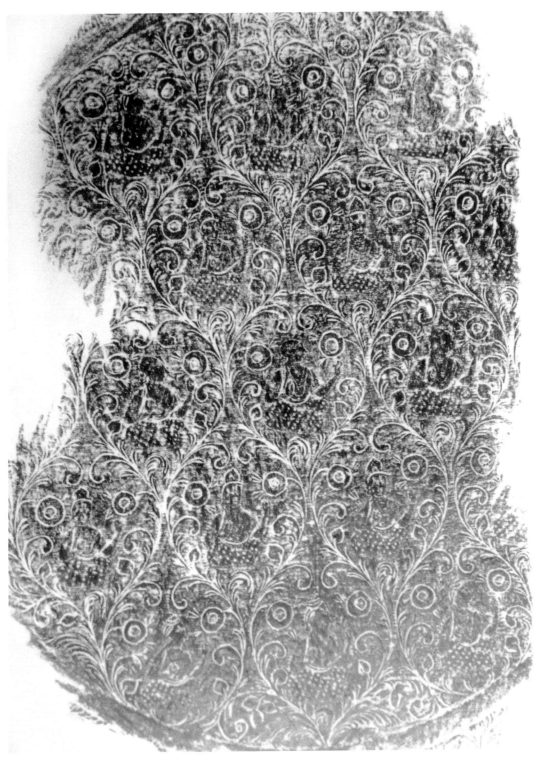

Rubbing of brass tray from India

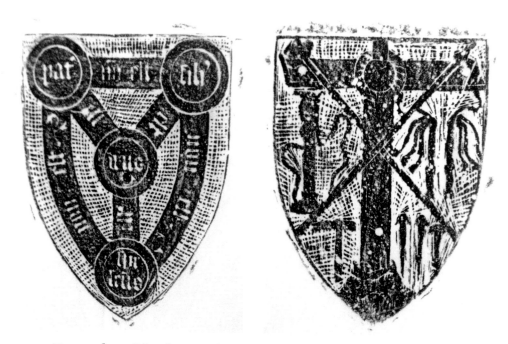

*Examples of flat brass plaque rubbings: Two coats-of-arms
from Winchester, England , rubbed with cobblers' wax*

The perfect spiral rubbing, seen below, is a cross-section of the nautilus shell sliced in half and shows the interior structure of its chambered shell. The other side of the shell was curved, so I had to press the paper around the shell. Isn't Nature perfect in its forms and symmetry? Where else in Nature or in the Heavens might you see these same designs?

*Two rubbings
of chambered
nautilus shells,
interior cross-
section (left)
and outer shell
surface (right)*

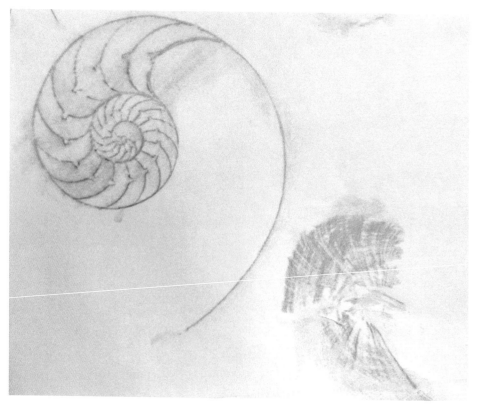

The Art and Adventure of Making Rubbings

Below are two examples of Native American basket-weaving designs seen from the bottom of two baskets. The contrasted basketry technologies—coiled versus plaited—become more evident when viewed as a result of rubbing.

This circular rubbing was made on the underside of an open-weave coiled basket woven of bear grass and yucca. I thank the artist who made the basket, which I bought and used for rubbing, Amelia Ramon, a native Tohono O'odham craftswoman from Gu Achi, Arizona.

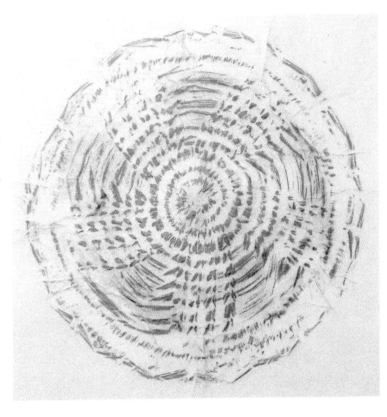

Rubbing of a Tarahumara single-weave plaited wari basket made of bear grass, a useful style of sifting or drying basket made by Native Rarámuri People of Chihuahua, Mexico. Note how the act of rubbing the fibers brings forth a design pattern displaying the technology of the weaver.

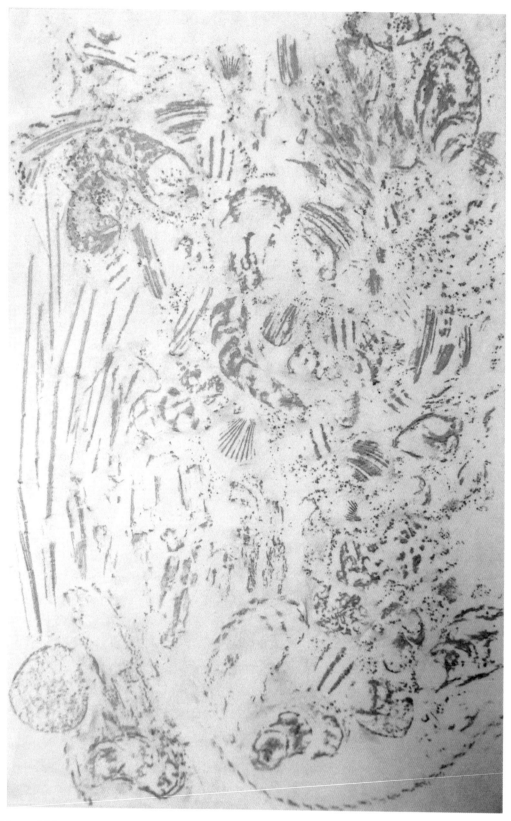

This rubbing was made on hard-packed, sun-dried sand at the beach containing a variety of seaside objects. What once-alive sea creatures and forces do you suppose left these intricate patterns and shapes that the waves brought together on the beach?

The Art and Adventure of Making Rubbings

Guess what all of these strange-shaped rubbings are made from...

Rubbing of the lower trunk "skin" of a living old giant saguaro cactus that had lost its spines

Rubbing of a dead yet standing saguaro cactus skeleton

The two preceding vertical rubbings are made from still-standing giant saguaro trees. The following five rubbings are from a dead saguaro skeleton cut horizontally. The only place the saguaro cactus grows is in the Sonoran Desert of the southwestern U.S. and northwest Mexico. This peculiar desert plant looks like a tall oblong green balloon that is made up mostly of watery tissue, like us humans, and is held up by a circle of wooden skeletal ribs, as seen in the cross-sections below. (Notice the different visual effects when rubbed with crayon, wax, and pencil.)

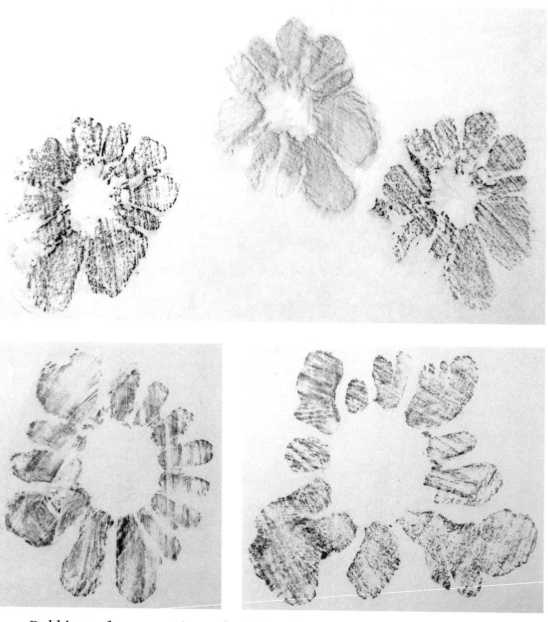

Rubbings of cross-sections of a fallen giant saguaro cactus skeleton,
each section cut and dried at different levels of its vertical height;
the widest section is from the base of its trunk. Top center rubbing is
with graphite pencil, black is cobblers' wax, red is crayon.

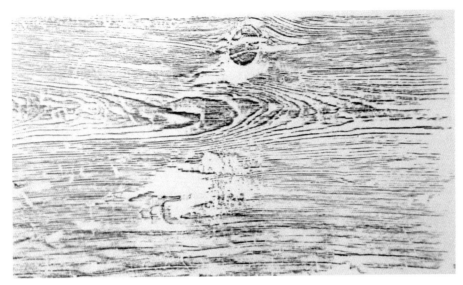

Rubbing of an old weathered mining ore box, showing interesting grain patterns of rough cut, weather-beaten lumber

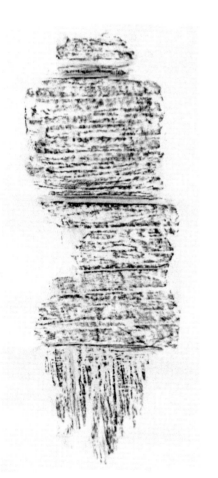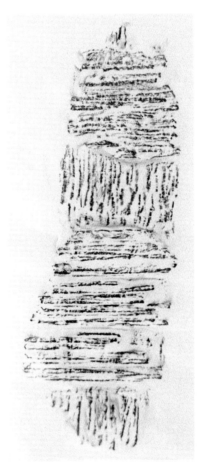

The wood for this lower pair of rubbings was once part of a three-layered plywood sheet. When that sheet fell into the ocean it was battered by the waves, for who knows how long, and got broken into smaller pieces that washed up onto the beach. The rubbings reveal the different layers of aged plywood seen on both sides. It looked to me like old pilings that held up a bridge, such as the bridge between Daytona Beach and New Smyrna, Florida, where I found it on vacation.

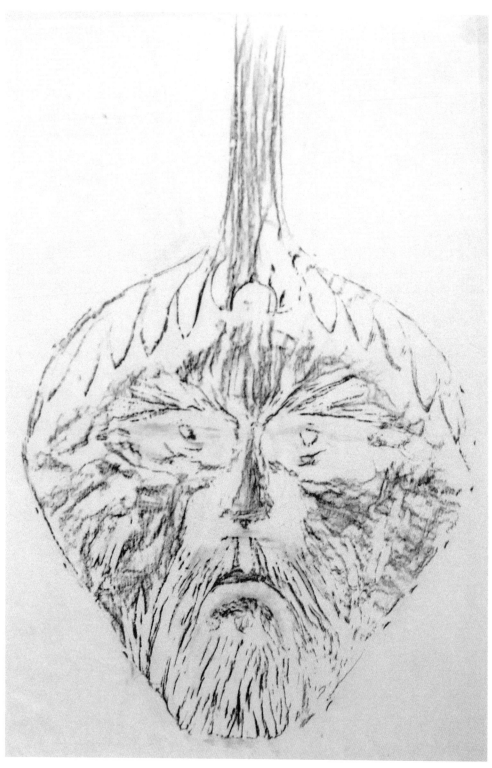

The antique bellows used for this rubbing was made of carved leather for the parts that hold the air, and of wood for the handles. Bellows are used for forges and furnaces to pump oxygen into the hot coals to get the fire hotter. I found this unusual piece at the historic Triangle L Ranch, Oracle, Arizona. They called it "The Face of the North Wind." What do you see in the design?

This rubbing is of a carved wooden "keystone" from the old mission church in San Javier, Baja California. A keystone is the top piece in the center of an arch that holds the arch together and sometimes has a decorated motif. How might you use this design in a composition? What does it remind you of?

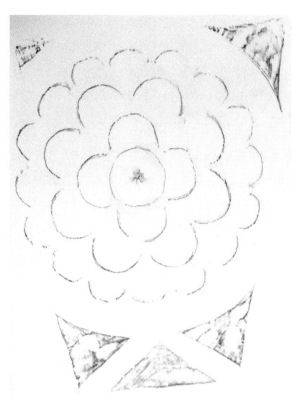

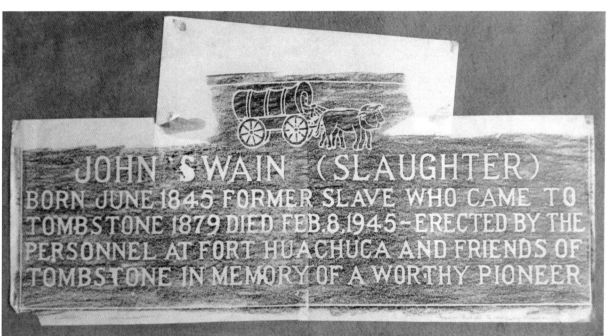

This is a rubbing I made in Boot Hill Cemetery, Tombstone, Arizona. All of the other grave markers were wooden crosses for the many outlaws and local cowboys buried there. Intrigued after rubbing this gravestone, I did more research and learned that John Swain (Slaughter) was an African-American pioneer who bought himself out of slavery and won the respect of his community. The soldiers from nearby Ft. Huachuca, Arizona, collected money to pay for this special granite headstone. Rubbing can spur you into interesting investigations.

There's a special story that you won't find in U.S. history books revealed in this rubbing! It took place when the American colonies had just declared independence from Great Britain. For years, local fishermen and oyster pirates fought each other for fishing rights to the prized oyster beds in the Chesapeake Bay at the mouth of the Rappahannock River. Both local fishermen and oyster pirates alike had to feed their families.

The fishermen who lived around Chesapeake Bay had fished there for generations and wanted to have the oyster beds to themselves. After the Revolutionary War was won, our new nation was governed by the Articles of Confederation, which allowed one state's vote to veto (or toss out) *any* proposed law or decision, making it hard to agree on anything because interstate decisions had to be unanimous. Representatives of the new states surrounding the Chesapeake Bay—Virginia, Maryland, and Delaware—met to find a way to stop the oyster bed fights.

George Washington invited the three representatives to meet first on the peaceful grounds of his plantation home, Mount Vernon. This meeting helped those men understand how big the problem was and that the current form of government, using the Articles of Confederation, was not good enough. As a result, they decided that our country needed to have a better way to help guide the people; they agreed that we needed a constitution to organize relationships and legal interactions between and among the new states. If they hadn't met there at that time, a constitution may never have been written, or might have been written at a later date.

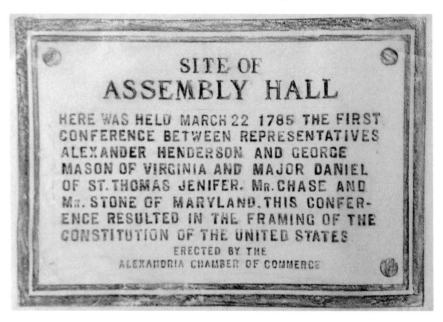

This rubbing was made directly from a plaque I found on an historic building in Alexandria, Virginia. It commemorates a meeting of representatives from Virginia and neighboring Maryland that gathered on March 22, 1785 (soon after Washington's Mount Vernon gathering), at which they decided to hold a constitutional convention to draft what became the document we still live by today—The Constitution of the United States.

Making Compositions with Rubbings

After you've made a lot of rubbings and are getting better at it, you might want to make rubbings of several objects, combining shapes from the different objects, to create a **composition**, such as these illustrations below.

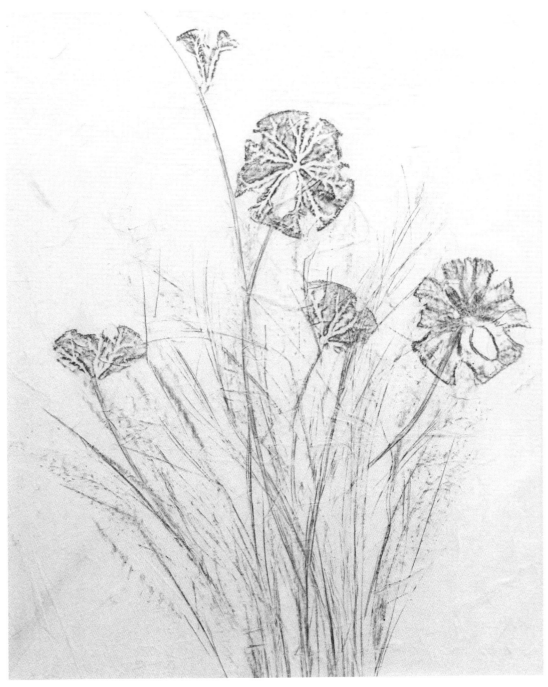

A rubbing composition—first, I made a rubbing of a little desert bush, mostly of the dry stems. Then I used sand dollars at the top of the stems to look like flowers. This meant I had to lift the paper and place each sand dollar in the composition before rubbing, sometimes only rubbing a part of the sand dollar.

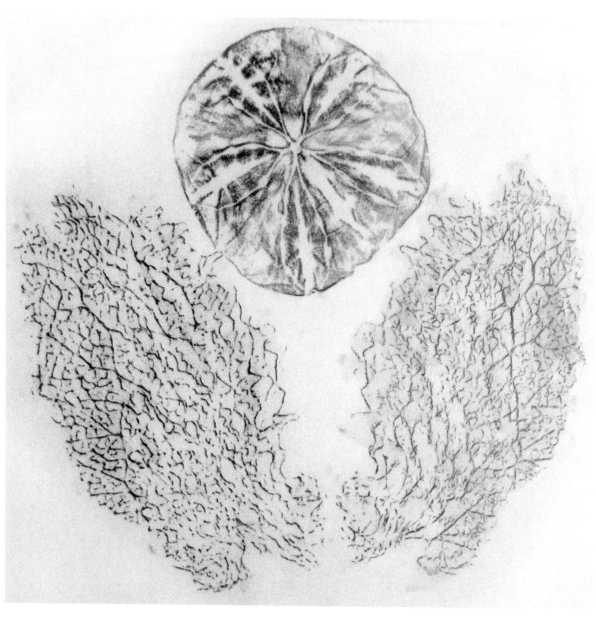

Another rubbing composition—the lacy rubbing on each side of the sand dollar was made from the dry intricate skeleton of a dead, weathered prickly pear cactus pad from the desert.

Mega-Rubbings

The actual scale of the grand Mega-Rubbing on page thirty-seven may be difficult to see. It is a full-size rubbing of a stele, a carved stone panel, of the god-king Ashurnasirpal II, King of Assyria. Before framing, the original rubbing was 87" high and stretched horizontally 74" wide.

Here is the backstory of this mega-rubbing: For years our family went to church and Sunday school in the Chapel of the Virginia Theological Seminary campus in Alexandria, Virginia. We never realized the significance of the giant stone housed unassumingly in the old Packard-Laird campus library that we walked right past every week.

In 1983, when my husband and I were packing for retirement to the Southwest, I was invited to a meeting of the Women of the Church, the last I'd be able to attend before we moved. The meeting was to view the "unveiling" in its new home of the bas-relief carving (that I had never previously noticed). The stone carving had been incorporated into an interior wall of the new Seminary Bishop Payne Library. The image in stone is of the winged figure of Ashurnasirpal II, King of Assyria (883-859 BC), almost 900 years before Christ. The stele, taken from excavations at Nimrud (ancient Calah, the Assyrian capital on the Tigris River, now northern Iraq), was given to the Seminary in the 1850s.

As we women gathered in amazement at the new display, I was electrified by the carving and its history and asked the librarian for permission to make a rubbing of it. Without hesitation, he said yes. I set to rubbing when I should have been packing. It took me a week to complete the over-seven-foot-high rubbing, using three tiers of rolled rubbing paper. Imagine the major effort to keep the large rolled paper "registered" in place, standing on a stool as I rubbed over the bas-relief contours of muscles, palm flowers, wings, and clothing. It became a tour-de-force, a meditation, and a major effort. When finished, the combined rubbing sheets stood far above my head.

Now, inspired to know more about Ashurnasirpal II, I found that this stele carving is one of many carvings of him that are very similar to this one, excavated at Nimrud. These beautiful ancient relics can be seen in person at such places as the British Museum. Search his name on the Internet for many eye-opening images. As of this writing, the interesting conclusions reached are that this is a unique carving and that mine is the only such rubbing known to have been made from it. Hence, details revealed in this rubbing may be of significant importance to archaeologists.

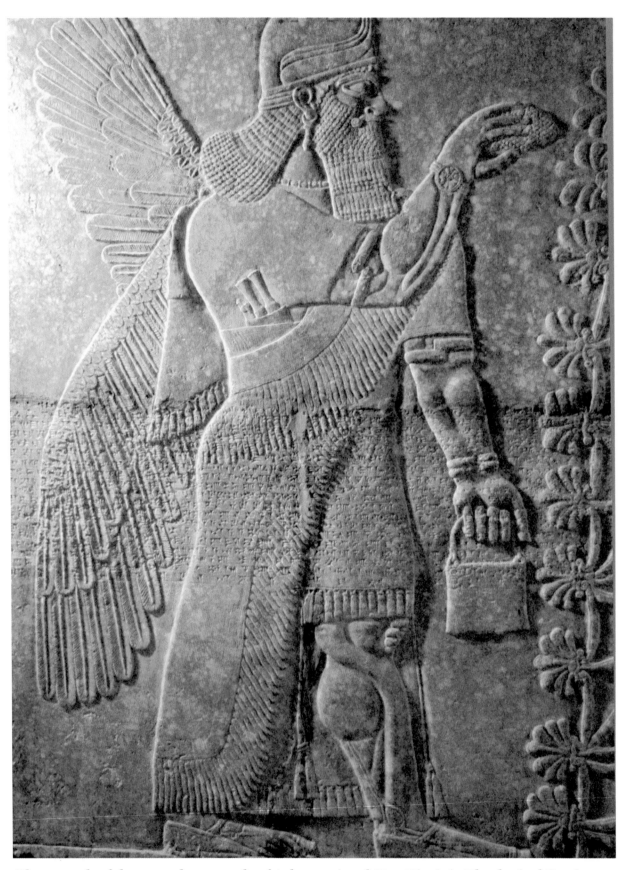

Photograph of the carved stone stele of Ashurnasirpal II at Virginia Theological Seminary. Photo courtesy of Virginia Theological Seminary Archives, Bishop Payne Library.

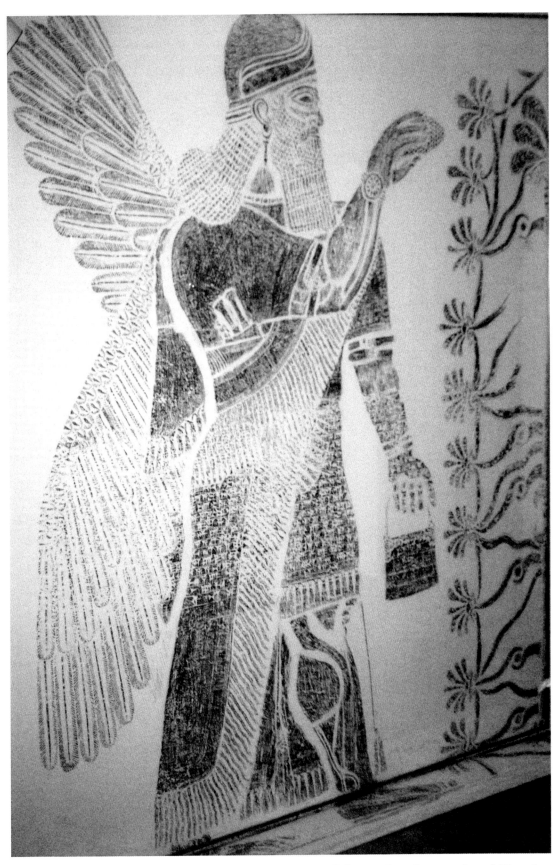

Mega-rubbing by the author Virginia Ames of the VTS Ashurnasirpal II stele

The Art and Adventure of Making Rubbings 37

The photograph on page thirty-six portrays the actual stone carving, or stele, of Ashurnasirpal II, in place at the Bishop Payne Library. Note how the photographer used a sideways light source to accentuate the relief of the carving.

My technique of rubbing this stele, seen in the illustration on the previous page, expresses the same relief patterns with an entirely different character. Both methods—photography and rubbing—depict the larger-scale details, including wings, palm flowers, muscles, beard, and helmet, quite vividly. However, notice how the *rubbing technique* reveals *additional* items: an arm bracelet, line after line of cuneiform writing on his clothing, a repeated pomegranate design on his shoulder-cloth, surprising details that can be of great importance to an historian. In fact, as the rubbing artist, even *I* did not notice them until the rubbing was *finished*! Such details only emerge with **the rubbing process.**

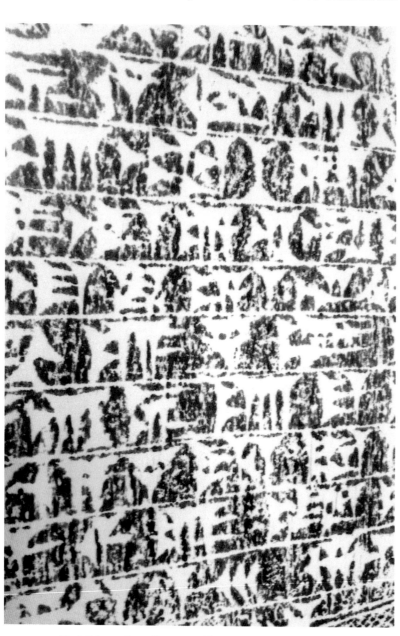

My rubbing is the only one known to be made of this particular stele of Ashurnasirpal II, and its details, shown in the several illustrations to follow, reveal secrets from the stone that may never have been seen before.

Rubbing detail: cuneiform writing on the stele of Ashurnasirpal II

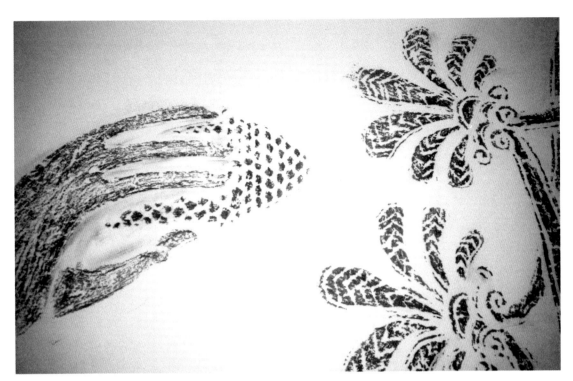

Rubbing detail: the god-king of Assyria, Ashurnasirpal II, performing the ceremonial pollination of the "sacred tree" that may have been the date palm

Rubbing detail: Ashurnasirpal II's earring and tightly curled beard

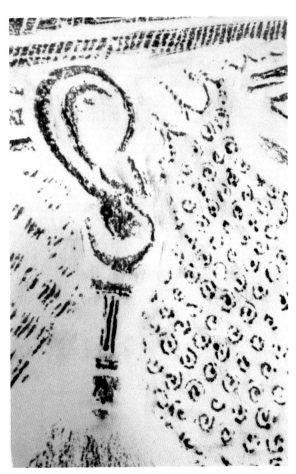

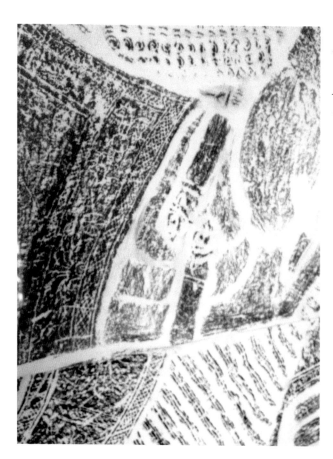

Rubbing detail: right arm bracelet of Ashurnasirpal II depicting a viper

Rubbing detail: left arm bracelet of Ashurnasirpal II, form of another snake

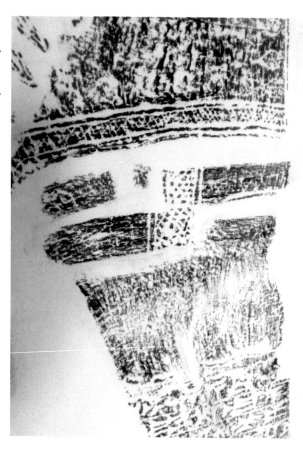

*Rubbing detail:
wrist bracelet of
Ashurnasirpal II*

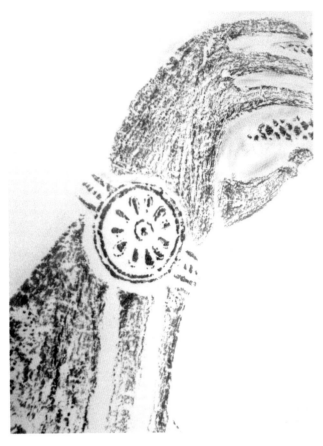

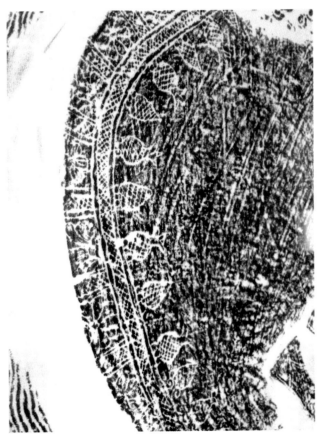

*Rubbing detail:
repeated design
of pomegranate
flowers on the
shoulder wrap of
Ashurnasirpal II.
Note the similarity
to Diné (Navajo
Nation) silverwork
influenced originally
by Spanish design
from the Moors of
North Africa*

[**Author's Note:** The stones found in Tel Nimrud by archaeologist Austen Henry Layard in the 1845 excavations were largely sent to Britain and other museums around the world. This one was excavated in 1857 by Austen Henry Layard.

"The Assyrian Reliefs (now housed in the Bishop Payne Library in the Virginia Theological Seminary, Alexandria, Virginia) were originally part of the walls of the palace and temples built in Calah (Nimrud) by Ashurnasirpal II (884 – 860 BC). They are made of gypseous alabaster. The human head figure is from the south end of the king's palace, (referenced as winged Diety or winged protective spirit) ... The ceremony depicted in (this) relief is the fertilization of the sacred tree from buckets filled with holy water or sacred pollen. The inscription, in Akkadian, gives the titles and genealogy of the king, describes his military conquests and concludes with an account of the rebuilding of the capitol. The reliefs were probably acquired by Dr. Henri B Haskell, a friend of Dr. Joseph Packard and were sent to America in 1859." http://www.vts.edu/podium/default.aspx?t=120356&rc=0. Dates of Ashurnasirpal II's life differ here from other sources.

I found in Wikipedia at https://en.wikipedia.org/wiki/Ashurnasirpal_II, a list of the known relief locations around the world, but interestingly enough, the one in Virginia is not listed.

I also found a book published in 2010 about Assyria, history and culture, and the meanings of the reliefs found at the Ashurnasirpal II palace. A book description can be found at http://searchworks.stanford.edu/view/8551188.]

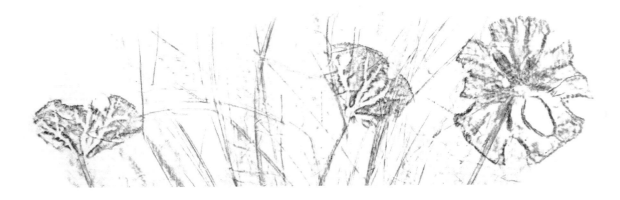

5

Where Can You Go From Here with Your Rubbings?

Your skill at rubbing, and your creativity in making new compositions with your rubbings, will grow with practice.

You will be able to do so many things with your rubbings! Here are a few ideas to get you started:

- Use smaller rubbings as **note cards**.

- Include your rubbings in an **art journal** or in a **field notebook** for remembering the plants, textures, rocks, feathers, etc. that you have seen on a trip or hike.

- Make a **scrapbook** or **reference collection** for future artwork and collages, or as a way to remember what and why you have chosen each thing to rub.

- Make unique **wrapping paper** on a larger sheet of paper or on a roll of shelf paper by making repeated rubbings of leaves, rough fabric, bark, wood, or ironwork with colored crayon or pencil. The repeated shapes or patterns become interesting wrapping paper for gifts.

- On a larger sheet of rubbing paper, compose a **collage** or "painting," using multiple rubbings designed to create an artsy new **composition**.

Some of the rubbings you create will be just for fun, produced in the moment to see the designs of something that has caught your eye or piqued your curiosity. Other rubbings will take on more significance. You may decide, once you see what has been revealed, that some of your rubbings must be kept, preserved, and even framed and displayed. There is no wrong way to make or use a rubbing.

A Word of Encouragement

All of the examples included from my own explorations in rubbing can serve as inspiration or as a takeoff point for *you*, the **explorer-artist**. I hope you, too, can find even more exciting things to rub.

May you make new discoveries by seeing old surfaces anew through the process of ***rubbing***!

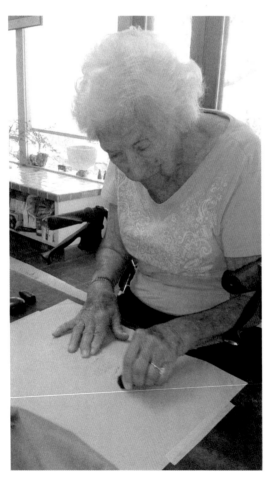

*Author
Virginia Ames
working on
a rubbing*

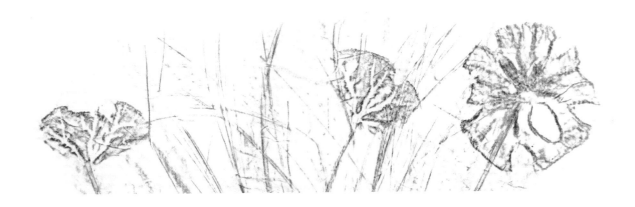

Acknowledgments

My deep gratitude goes to the following people for making this book possible:

- The librarian at the Virginia Theological Seminary (VTS) Bishop Payne Library who gave me permission in 1983 to rub the stele of Ashurnasirpal II.

- The current Head Librarian at Bishop Payne Library, Professor Mitzi Budde, who was instrumental in obtaining permission for me to use the photo of Ashurnasirpal II from the Bishop Payne Library in this book; and the VTS Archives Department which provided additional historical details of the stele.

- Austen Henry Layard, the archeologist who originally excavated the stele relief, and Henri Haskell, who facilitated the transfer of the stele to the Virginia Theological Seminary—rest their souls!

- Janis Howatt Willkom, who helped me "excavate" my lifetime of rubbings and document them.

- My spirited assistant, Twinfeathers, who helped me research details, type, assemble, and polish the manuscript.

- Martha Ames Burgess, my daughter, who spent countless hours assisting in the editing, layout, photography, and publishing process, without whom I could not have completed this book.

- The creative team at www.MyWordPublishing.com: publishing consultant Polly Letofsky, editor Donna Mazzitelli (www.merrydissonancepress.com), and layout designer Gail Nelson (e-book-design.com), for seeing it through!

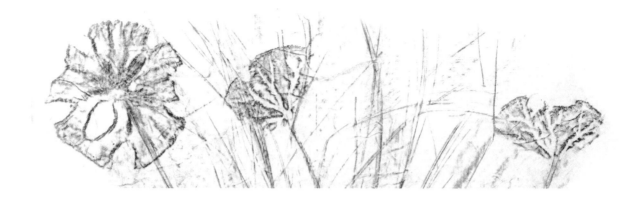

About the Author

Virginia Wade Ames (Born November 6, 1914)

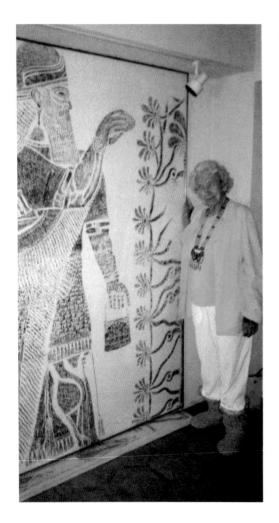

Artist and writer Virginia Wade Ames recently published her first book *The Wayfarers: Journeying through a Century of Change* and has more manuscripts in the works. She has been an artist in many mediums all her energetic and interesting life, from the East Coast to the Southwest. Since moving to Tucson, Arizona, in 1983, she has had numerous shows of her paintings, was a drawing instructor at the University of Arizona SAGE-OLLI Society and an active member of the Southern Arizona Watercolor Guild for many years.

She began writing early on for the Alexandria, Virginia, paper, *The Port Paquet*, and developed a weekly column connecting current events with similar events from Alexandria history—her own unique and amusing approach to reporting local news.

Now with diminished eyesight, she has shifted her creativity to "painting with words" rather than with the brush or cobblers' wax.

Made in the USA
Columbia, SC
23 July 2021